Gris Grimly's Wicked Nursery Rhymes

Gris Grimly

BABY TATTOO BOOKS

Dedicated to Heinrich Hoffmann for showing us what
Children's Literature should be.

G.G.

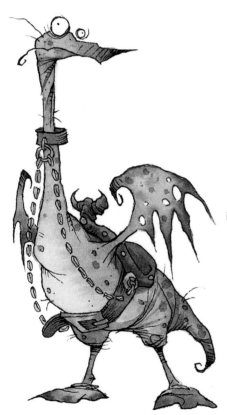

ISBN 0-9729388-7-7
Library of Congress Control Number: 2003091282

10 9 8 7 6 5 4 3 2

Published by Baby Tattoo Books
6045 Longridge Avenue
Van Nuys, California 91401
www.babytattoo.com

Designed by eric@pixelectomy

Manufactured in China

CONTENTS

FATHER GRIM — 4

MISS MUFFET — 6

FUZZY WUZZY — 10

JACK AND JILL — 12

MISTRESS MARY — 20

JUMPING JOAN — 24

LITTLE BO PEEP — 26

NIMBLE JACK — 28

FATHER GRIM

Gris Grimly travels near and far to find where naughty children are.
He searches for them in the night, instructing them with tales of fright.

If you behave like children should, doing things both kind and good,
then you will find, just wait and see, blessings shall befall on thee.

But if you are a wicked rook, like those inside this picture book,
then life's misfortune shall befall upon you who are weak and small.

After his instruction's through, he leaves to go find someone new.
When he chooses to meander, he flies away upon his gander.

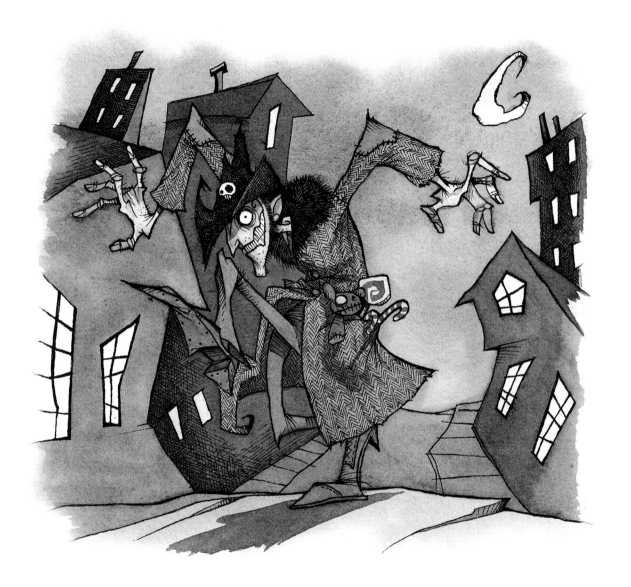

MISS MUFFET

Little Miss Muffet, a wicked child,
had manners that were crude and wild.

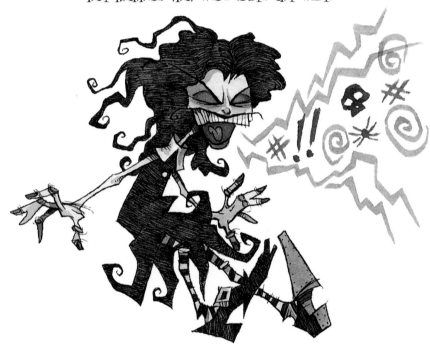

She would scream, curse, spit and swear.
She said things children wouldn't dare.

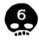

To other classmates, she would be cruel,
and so she made no friends at school.

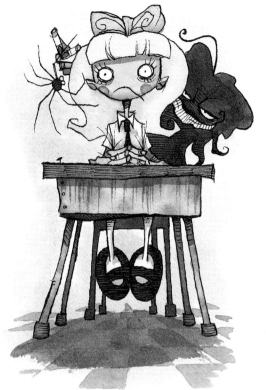

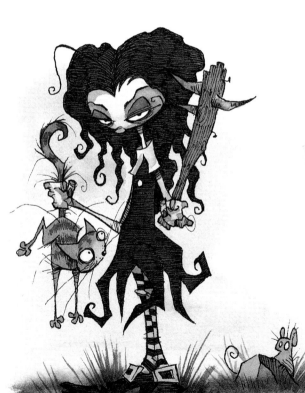

Here you see why creatures feared
the girl when she would venture near.

When ma and pa could take no more
they opened up the cellar door.
They tossed her down the stairs and then
they never let her out again.
She ate naught, but curds and whey
that was handed through a slot each day.
The spiders crawling through her hair
were all the friends she had down there.
All alone, she wept and cried
and stayed in the cellar 'til she died.

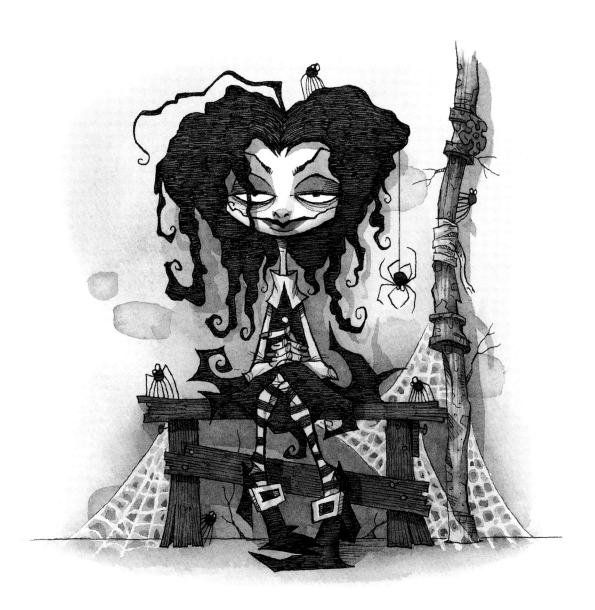

FUZZY WUZZY

A poor wretched bear was named Fuzzy.
Still the question remains, "But was he?"
Born with no hair,
he was oddly bare,
and a little bit stinky and scuzzy.

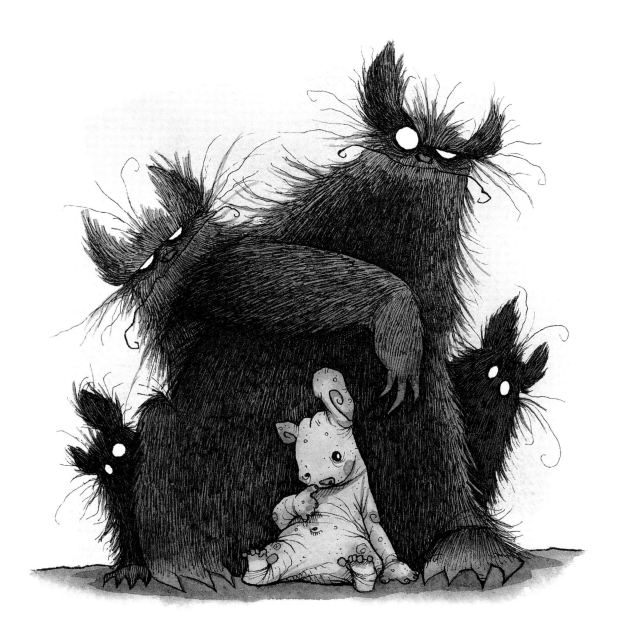

JACK AND JILL

Jack and Jill were born at noon.
They began to quarrel soon.

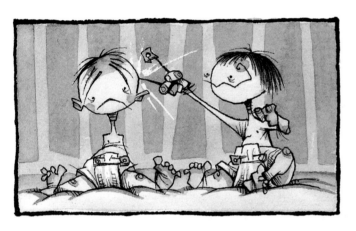

Jill would jab him with a pin
while she bared an evil grin.

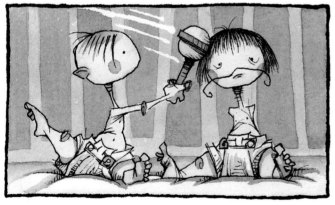

Jack would bash her on the head,
without guilt, until she bled.

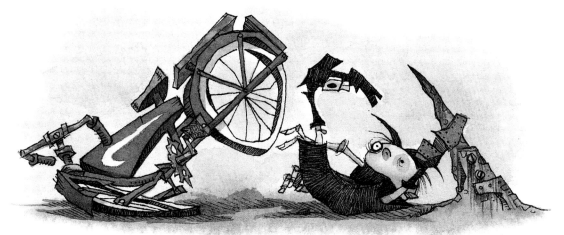

Jill would knock him off his bike in hopes he'd land upon a spike.

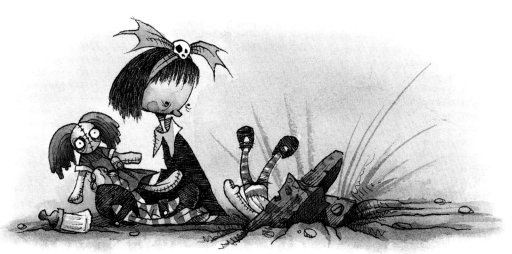

Jack would drop an iron weight inches from a gruesome fate.

One day they were sent up hill
to fetch some water in a pail.

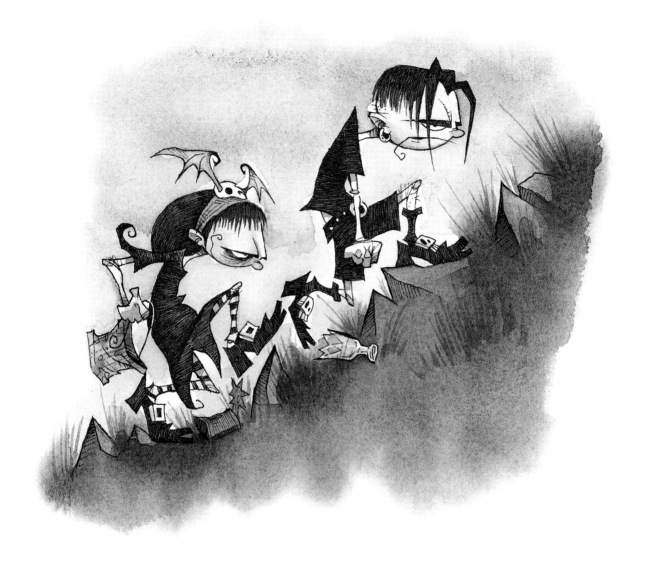

Jill pushed Jack unto his death
when he had paused to catch his breath.

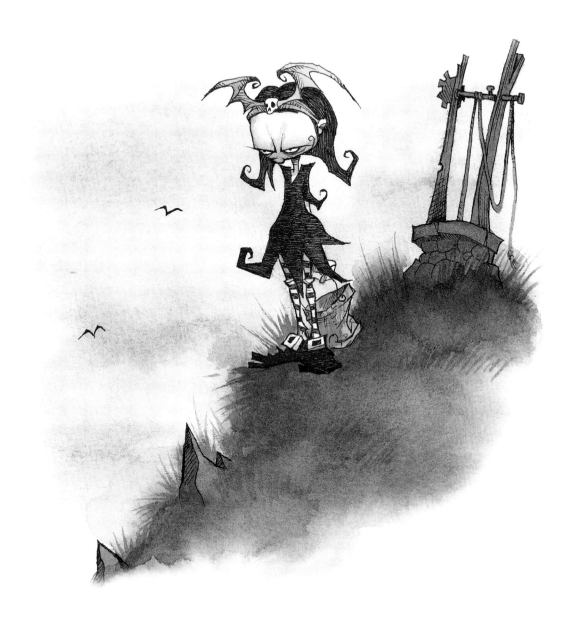

She felt remorse for the first time
and threw herself not far behind.

MISTRESS MARY

There once was a girl named Mistress Mary
who planted a garden quite extraordinary.
The plants that she grew were strange and unique.
They caused men to quiver and women to shriek.

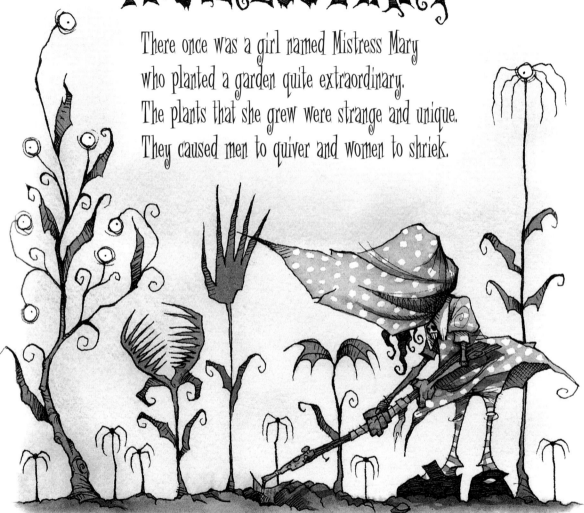

Along came the maidens, with blonde maiden hair,
who thought Mary's garden shouldn't be there.

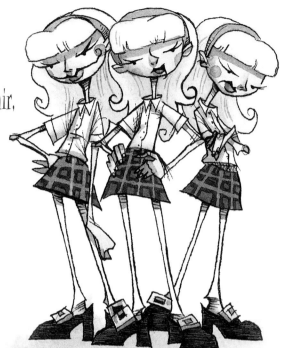

They trampled the garden (every last bud)
and then pushed poor Mary right into the mud.

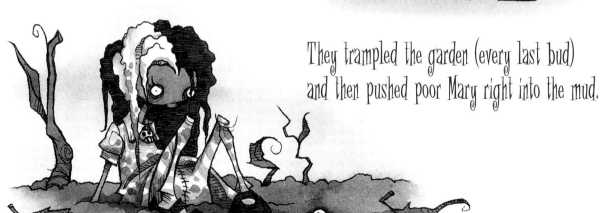

The next day the maidens were nowhere to be found
and Mary had a new garden planted in the ground.

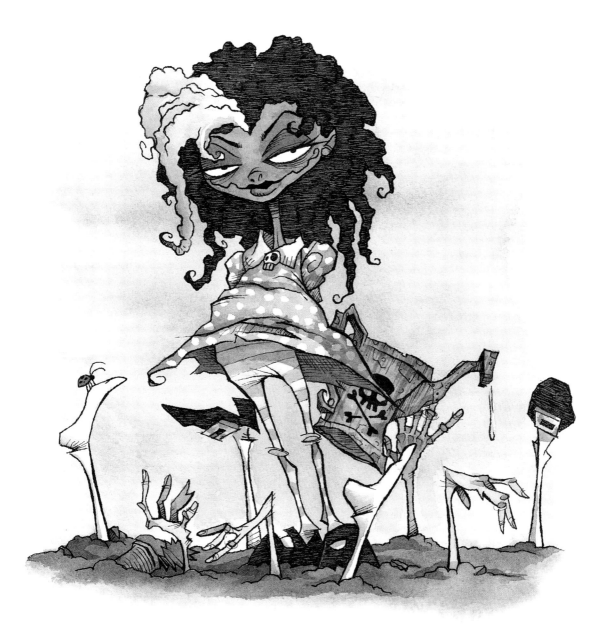

JUMPING JOAN

There once was a girl named Jumping Joan,
who spoke no words but only moaned.
When heard she was dead,
her classmates all fled.
Now little Joan plays all alone.

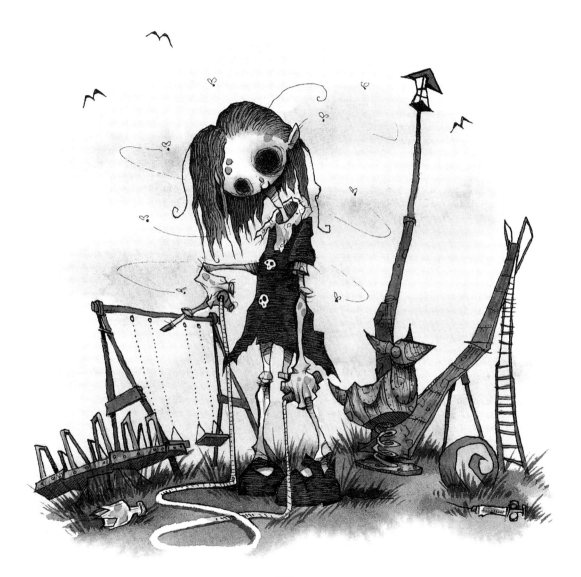

LITTLE BO PEEP

"I think I have too many sheep,"
said a girl named Little Bo Peep.
"They never fail to flee and wander.
The pretty grass, they tend to squander.
They cry a horrid sound all week.
They smell an awful pungent reek."
She thought about what should be done,
and then went on to eat each one.

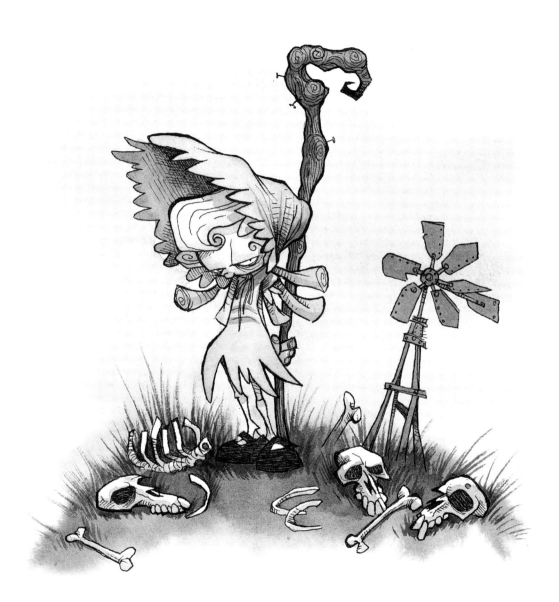

NIMBLE JACK

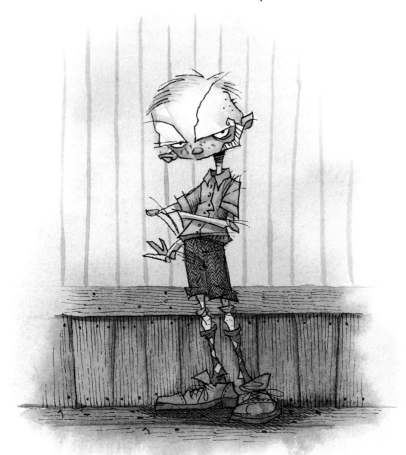

Foolish Jack, here you see,
Thinks he's nimble as can be.

The banister he'll hurry down.
He's not afraid to break his crown.

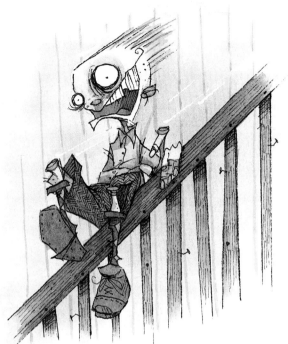

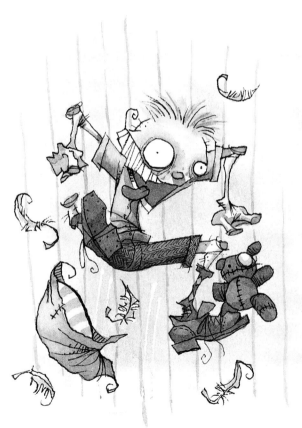

He'll bound upon his springy bed.
He's not afraid to bang his head.

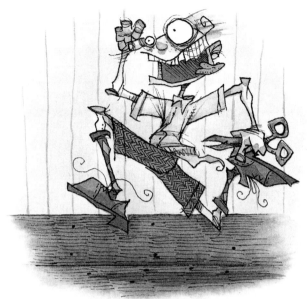

He'll scamper up and down the hall.
He's not afraid if he should fall.

In the tub he'll splash and skip.
He's not afraid if he should slip.

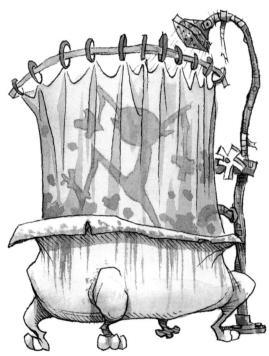

He'll tip and teeter on his chair.
He's not afraid to fall from there.

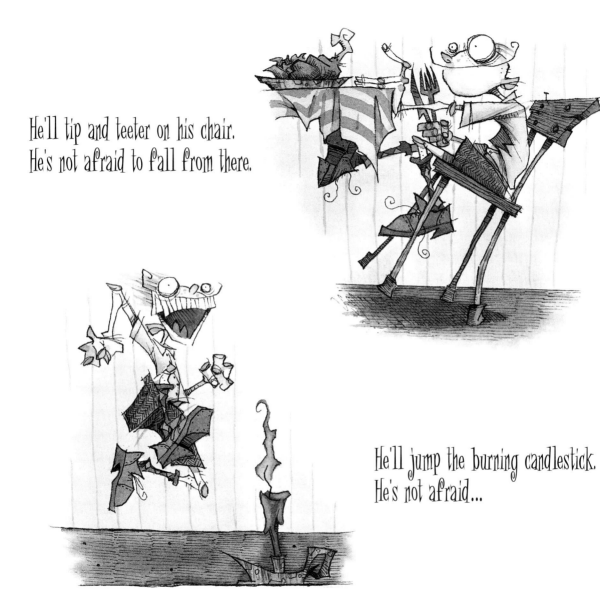

He'll jump the burning candlestick.
He's not afraid...

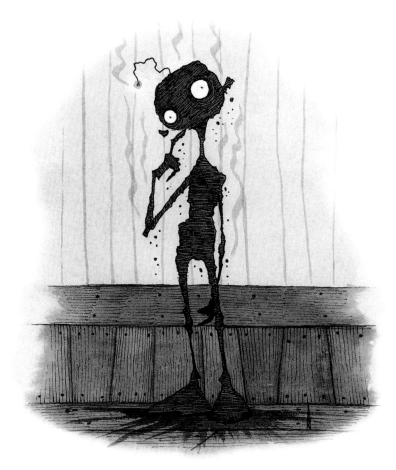

...stupid Jack.